The Bob Ross Cookbook

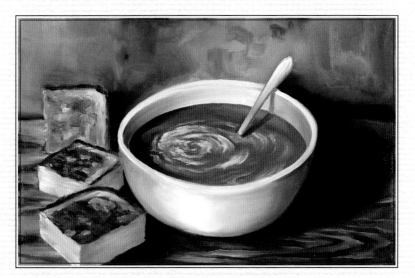

Happy Little Recipes
for Family & Friends

The *Bob Ross*® Cookbook

Happy Little Recipes for Family & Friends

Robb Pearlman

Paintings by Bob Ross and Nicholas Hankins

RUNNING PRESS

PHILADELPHIA

Running Press
Hachette Book Group
1290 Avenue of the Americas, New York, NY 10104
www.runningpress.com
@Running_Press

Printed in China

First Edition: May 2020

Published by Running Press, an imprint of Perseus Books, LLC,
a subsidiary of Hachette Book Group, Inc.
The Running Press name and logo is a trademark of the Hachette Book Group.

The Hachette Speakers Bureau provides a wide range of authors for speaking events.
To find out more, go to www.hachettespeakersbureau.com or call (866) 376-6591.

The publisher is not responsible for websites (or their content)
that are not owned by the publisher.

Food paintings by Nicholas Hankins.

Print book cover and interior design by Josh McDonnell.

Library of Congress Control Number: 2019951193

ISBNs: 978-0-7624-6913-0 (hardcover), 978-0-7624-6912-3 (ebook)

1010

10 9 8 7 6 5 4 3

Contents

PART THREE: *Fish*

PART FOUR: *Chicken*

PART FIVE: *Vegetables*

PART SIX: *Soups, Salads, and Other Things . . .*

Introduction

To those who ask, "A Bob Ross cookbook?" I say, "Yes."

Cooking and painting go together as naturally as fluffy little titanium white and cadmium yellow–colored eggs and dark sienna–colored bacon. For years, Bob Ross's *Joy of Painting* series aired on PBS stations alongside other educational and entertaining programs. But perhaps the best accompaniment to Bob's painting was the cooking shows, like Julia Child's *The French Chef*, because painting and cooking share so many of the same core ideas. You could paint or cook for yourself, but isn't it more fun, and more rewarding, when you share the final product with friends? You could paint by numbers, or follow recipes to the letter, but isn't it more enriching to add a few colors, a few ingredients, just to see where they take you? You could toss away a painting that looks too dark, or a soup that tastes too bland, but isn't it thrilling when you're able to find just the place on the wall where the sunshine catches the canvas and brings out the nuances of your work? And when you find just the right amount of seasoning to bring layers of flavor out of the soup?

Painting and cooking are about creation. They are about discovering what you can do. They are about trial and error and learning from mistakes. They can each be a meditative experience in which, just for a little bit, you can forget the world and focus solely on yourself, and your task.

The recipes in this book are inspired by Bob Ross's life, work, and the tools he gave us to experience life to the fullest and to express ourselves. Simple comfort foods using natural and unprocessed ingredients, they allow for—and encourage, as Bob would want—home cooks to try and experiment with variations of their own so each dish, as each painting, can become its own unique project.

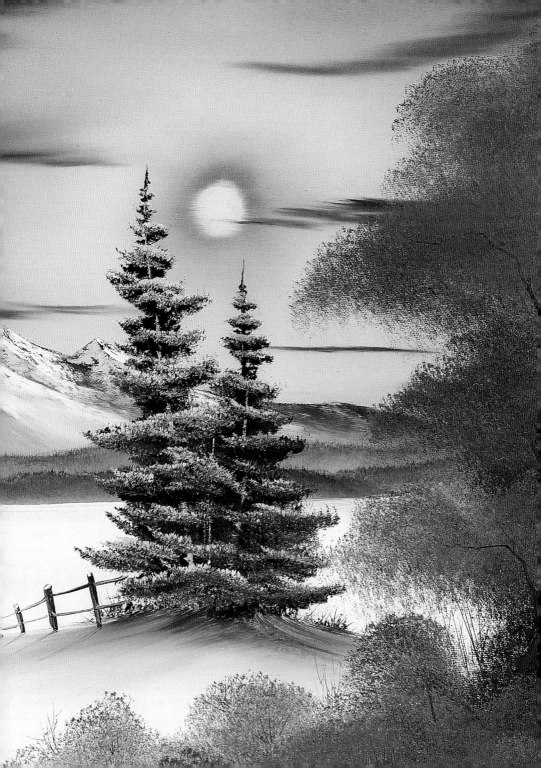

Part One

Beef, Chili, Roasts, and More

"If what you're doing doesn't make you happy, you're doing the wrong thing."

Peapod's Chili

Like most squirrels, Bob's little friend Peapod was an adaptable sort who was able to find his place in the trees, bushes, and underbrush that Bob would paint (and walk around, at locations such as his homes in Alaska and Florida). This recipe, like Bob's instructions, is a framework for you to add to for your own signature chili and, like good ol' Peapod, can add some fun and adventure to your weeknight meal!

SERVES 4 TO 6

12 ounces/240 g ground beef

1 teaspoon olive oil

1 (15-ounce/430 g) can kidney beans

1 cup/260 g salsa

½ cup/70 g corn kernels, frozen or fresh

½ onion, chopped

14 ounces/410 g tomato sauce

1 cup/120 g shredded Cheddar cheese

Tortilla chips

In a large pot, brown the meat in the oil over medium heat until no longer pink.

Add the undrained beans, salsa, corn, onion, and tomato sauce.

Cook, covered, for 30 minutes, then uncovered for another 15 minutes to thicken.

Top with the cheese and garnish with the chips.

Bravery Test

Let your imagination be your guide. There are absolutely no limits here. Try adding different chopped vegetables, such as happy little broccoli trees, cauliflower, red peppers, green beans, or even leafy greens, like kale and spinach, to sneak in some additional nutrition! You can also add 1 teaspoon of red pepper flakes for an additional bit of heat, or 1 teaspoon of fresh cilantro as a highlight.

Nothing to It Pot Roast

In addition to filming his television show, Bob spent a great deal of time traveling around shopping malls across the country teaching crowds of students—many of whom had nothing in common but a desire to paint. Although the juxtaposition of teaching art in bastions of consumerism may seem jarring, Bob knew that there was no wrong place to be creative, and that artists, like himself, could benefit from modern conveniences. I don't think it's much of a stretch (at least less of a stretch than one of his canvases) to liken this recipe to Bob's touring experience: It adds a modern convenience—in this case, packaged onion soup—to a crowded combination of meat and vegetables, and gives them the time to work together, and separately, to create something every family will love.

But as Bob would say, "When you're doing this at home, I really recommend you don't do this in your living room!"

SERVES 6

2 tablespoons/30 g unsalted butter

1 teaspoon oil

1 large onion, cut into chunks

3 pounds/1.4 kg boneless roast beef

3 cups water/710 ml

1 (1-ounce/28.3-g) package onion soup mix

3 carrots, peeled and chopped

3 medium-size potatoes, chopped

Preheat the oven to 375°F/190°C.

In a large roasting pan, heat the butter and oil over medium heat.

Add the onion and beef and cook until the beef is browned on all sides.

While that's cooking, combine the water and onion soup mix in a saucepan. Bring to a boil.

Add the carrots and potatoes to beef mixture, then add the onion soup mixture.

Cover, place in the oven, and bake for 2 to 3 hours, or until the meat is cooked through. By allowing these flavors to blend in the oven, you get a multitude of different values and aromas rather than just one old flat taste. Let rest for 10 minutes before slicing.

Footy Hill Salisbury Steak

Bob often painted brighter, lighter highlights on at the last moment to set off the darker planes and features of his scenes. This recipe calls for a last-minute addition of stock, wine, and thyme, which, when blended, brings out the depth of flavor in the relatively simply prepared meat. Reminiscent of the sights and smells of an outdoor cookout, these basic little shapes pack in a lot of flavor so you can put some excitement into your world.

SERVES 4

3 tablespoons/50 g all-purpose flour, divided

1¼ pounds/570 g ground beef

¼ cup/20 g minced fresh parsley

2 tablespoons/10 g finely chopped scallions

1 teaspoon salt

1 teaspoon freshly ground black pepper

1 tablespoon vegetable oil

2 cups/320 g sliced onion

1 teaspoon sugar

1 tablespoon chopped garlic

1 tablespoon tomato paste

2 cups/480 ml beef stock

¼ cup/60 ml red wine

½ teaspoon dried thyme (And speaking of thyme, when was the last thyme you painted, or cooked something just for yourself?)

Put 2 tablespoons/30 g of the flour in a shallow bowl. Set aside.

Combine the meat, parsley, scallions, salt, and pepper in a separate bowl. Divide the mixture and shape into 4 patties.

Place each patty in the flour, coating on all sides.

Heat the oil in a large skillet over medium heat until hot. Add the patties and sauté until browned, 3 to 4 minutes per side. Remove from the pan and let cool slightly.

Add the onion and sugar into the pan and sauté over medium heat until golden brown, 5 to 6 minutes. Add the garlic and tomato paste and stir for about 1 minute. Sprinkle the remaining tablespoon/20 g of flour on top and stir until the flour browns.

Stir in the stock, wine, and thyme until fully incorporated. Add the patties back to the pan and bring to a boil. Lower the heat and simmer for another 10 minutes.

Work It Work It Work It Meat Loaf

Just like working paint into a canvas, you're going to *work it work it work it!* I like using three different kinds of meat in my meat loaf. It adds an interesting layered flavor experience, but this is your meat loaf, so let your imagination take you wherever it wants to go!

SERVES 4 TO 6

¾ cup/80 g breadcrumbs

⅓ cup/80 ml/ milk

½ cup/120 ml ketchup

⅛ teaspoon red wine vinegar

1 heaping tablespoon/20 g brown sugar

1 large onion, diced

1 tablespoon vegetable oil

1 pound/460 g ground pork

1 pound/460 g ground beef

1 pound/460 g ground veal

3 tablespoons/50 ml Worcestershire sauce

2 teaspoons salt

2 teaspoons freshly ground black pepper

2 large eggs, beaten

Preheat the oven to 350°F/180°C.

In a large bowl, mix together the breadcrumbs and milk and set aside.

In another bowl, mix together the ketchup, vinegar, and brown sugar and set aside.

In a skillet, sauté the onion in the oil over high heat until golden brown. Remove from the heat and let cool.

Add the pork, beef, veal, cooled onion, Worcestershire sauce, salt, pepper, and eggs to the breadcrumb mixture.

Use your hands to really *work it work it work it* (the ingredients, that is) together in the bowl. Being careful not to add too much pressure, form a firm, but not packed, loaf. Press into a 9 x 5 x 3-inch/23 x 12 x 7.5-cm loaf pan.

Use a brush to coat the loaf with the ketchup mixture, then bake for about 1½ hours, or until rich golden brown, just as it's beginning to darken with crispy bits all around.

"And begin thinking about form and shape in form in here."

Van Dyke Browned Meatballs

Some people prefer to use a spoon or spatula to mix the meat, and then an ice-cream scoop to form the balls. But I think the key to these meatballs is knowing—and feeling—the meat, and when to stop balling it up. I like them large enough to sit comfortably in my palm, no larger than an egg; and firm enough to keep their shape but not so densely packed that there's no air. You may like them larger or smaller, or to go without touching the meat at all, and that's okay. This is your kitchen—you can do whatever you like here!

SERVES 4 TO 6

1 pound/460 g beef or veal

1 small onion, diced

½ teaspoon garlic powder

1½ teaspoons Italian seasoning

¾ teaspoon dried oregano

¾ teaspoon red pepper flakes

1½ teaspoons Worcestershire sauce

½ cup/120 ml milk

¼ cup/30 g grated Romano cheese

½ cup/60 g unseasoned panko or breadcrumbs

Preheat the oven to 400°F/200°C.

In a large bowl, gently combine all the ingredients until incorporated.

Let the mixture rest for 3 minutes, and think about the last time you took a walk in nature. Then, form into balls of whatever size you like.

Place them on a nonstick rimmed pan. Bake, uncovered, for about 25 minutes, or until brown.

Once they're done, you can simmer them in the Bright Red Tomato Sauce (page 93) or your favorite jarred sauce. We'll just drop them in!

"It's hard to know
when to stop.
You can piddle
it to death."

Winter Scene Beef Stew

Bob taught us that a tree or a rock or even a thick coat of snow could cover up mistakes. It's really hard to completely mess up a painting. It's just as difficult, once you know the overall technique, to ruin a beef stew. This recipe could—and should—be subject to your own tastes, so let your imagination go!

SERVES 6

1 large onion, sliced

8 ounces/230 g carrots, chopped

8 ounces/230 g celery, chopped

1 cup/130 g all-purpose flour

1 teaspoon garlic powder

1 teaspoon onion powder

½ teaspoon cayenne pepper

½ teaspoon dried oregano

½ teaspoon dried thyme

½ teaspoon salt

3 pounds/1.4 kg stew beef

½ cup/120 g brown sugar

½ cup/120 ml chili sauce (you didn't think that could happen, did you?)

½ cup/120 ml ketchup

¾ cup/180 ml beef stock

Preheat the oven to 375°F/190°C.

Place the onions, carrots, potatoes, and celery in an oven-safe pot.

In a shallow bowl, mix together the flour, garlic powder, onion powder, cayenne, oregano, thyme, and salt. Dredge the meat in the mixture.

Add the peas and place the meat on top of the vegetables in the pot.

In a medium bowl, mix together the brown sugar, chili sauce, ketchup, and stock. Pour over the meat.

A great, and easy, thing about this recipe is that there's no need to brown the meat on the stovetop before placing in the oven! Bake, covered, for 3 hours, or until the meat reaches an internal temperature of 145°F/63°C.

"Just all kinds of
little things in there."

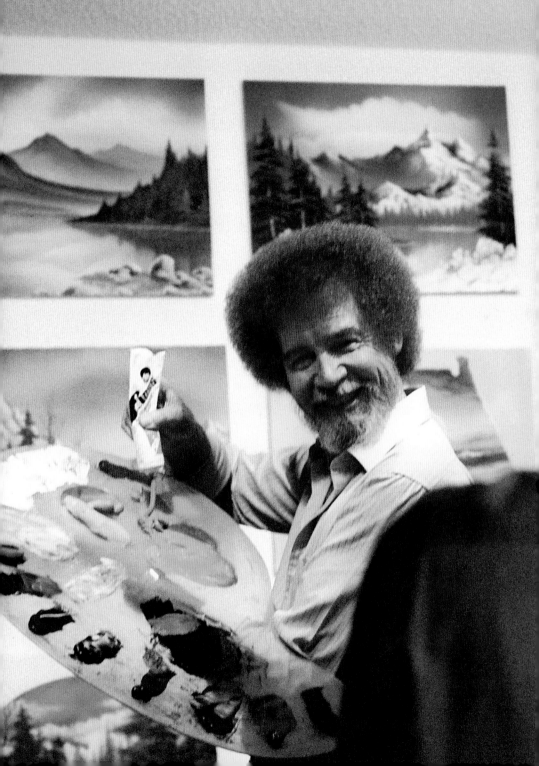

Part Two

Pork

"You're so very special."

Don't be afraid to go out
on a limb, because that's
where the fruit is.

Fruit with Pork Chops

Bob knew that despite your plan, sometimes the painting would tell you the direction you need to go. Although, technically, the pork chops are the star of this dish, I think it's the fruit that often steals the focus of this dish. You know, people who paint (and cook) have an artist's license that says they can do anything they want, so I prefer using apricots, mangoes, and peaches, as their natural sweetness works well with the pork and they really plump up from the liquid. But if the traditional pork chops and applesauce is more to your liking, try apples! Avoid freeze-dried fruits, though, as they tend to not rehydrate as well as traditionally dried fruits.

SERVES 4

4 pork chops

1 teaspoon dried thyme

8 ounces/230 g mixed dried fruit, cubed or diced

1 medium-size red bell pepper, seeded and diced

1½ cups barbecue sauce

Place all the ingredients in a large pot and cover. Simmer over low heat for 2 hours, or until the internal temperature of the pork reaches 145°F/63°C.

Bravery Test Add a tablespoon of your favorite fruit preserves (not jelly) to thicken and enhance the sauce.

Mountain-Moving Balsamic Pork Loin

Like a mountain in the background of one of Bob's paintings, balsamic vinegar can serve as a powerful backdrop ingredient that can serve as the backdrop for a whole landscape of flavors. By marinating the pork in the wet-on-wet mixture for several hours, you'll not only give the meat time to break down in a bath of seasoning, but yourself time to take a relaxing bath!

SERVES 4

½ cup/120 ml balsamic vinegar, which has a lovely deep red color

½ cup/120 ml olive oil

1 teaspoon garlic powder

1 teaspoon onion powder

¼ cup/80 g honey

2 pounds/900 g boneless pork loin

In a large bowl, whisk together the vinegar, oil, garlic powder, onion powder, and honey. Add the pork loin, cover, and marinate for 3 hours in the refrigerator. Look—we've already got all those good things happening!

Preheat the oven to 350°F/180°C.

Place the pork loin in a pan and roast for 1 hour, basting several times with the marinade prior to being fully cooked. Discard any leftover marinade. Let rest for 10 minutes before carving, to allow all the juices to settle.

"Didn't you know you had that much power? You can move mountains. You can do anything."

Good Thoughts
Pork Chops

This recipe may seem simple, but I promise that your guests will come back for seconds and thirds if you add in one last, simple ingredient: your good thoughts. Even in scenes featuring darkening skies, shadows, or snow-covered fields, the landscapes are imbued with a core of meditative recognition of the beauty of nature. I like to think that we get so much out of Bob's paintings because he infused each of them—as he did with each of his lessons and each of his television episodes—with all the same good thoughts he encouraged us to focus on.

SERVES 4

Olive oil for baking dish

2 tablespoons/30 ml freshly squeezed lemon juice

2 scallions, chopped

3 garlic cloves, minced

1 teaspoon dried rosemary

¼ teaspoon freshly ground black pepper

4 pork chops

1 tablespoon olive oil

Preheat the oven to 400°F/200°C.

Brush a baking dish with oil and set aside. Be sure to clean the brush before using it to paint! Actually, just use a different brush.

In a shallow bowl, combine the lemon juice, scallions, garlic, rosemary, and pepper. Dip each pork chop into the mixture until all sides are coated. Transfer to the prepared baking dish and drizzle a little olive oil on top of each chop.

Bake, uncovered, for 20 minutes, or until the internal temperature is 145°F/63°C.

Part Three

Fish

"You can create beautiful things."

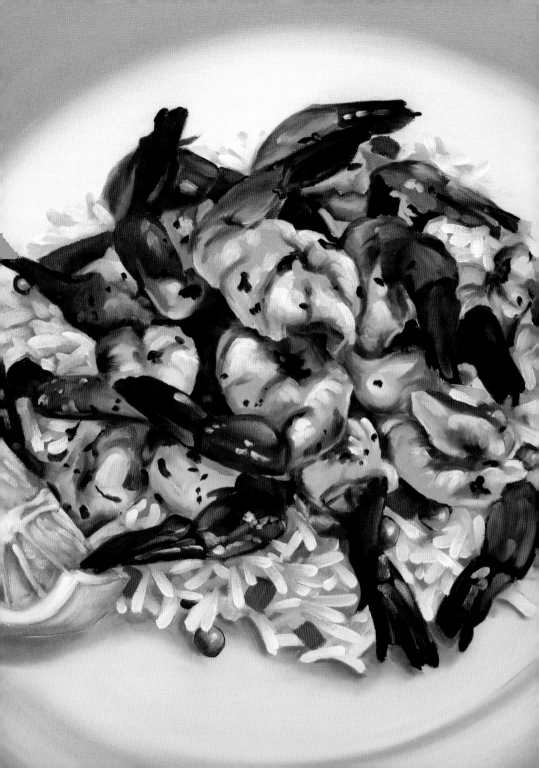

Golden Sunset Shrimp Scampi

Although mass-produced posters or photos are nice, the art you hang in your home will mean more to you, and your guests, if it's a reflection of your tastes, and it will certainly take on an even deeper importance if it's something that you've created yourself. Shrimp scampi can be ordered at pretty much any restaurant these days, but rather than eating something produced in a commercial kitchen, why don't you invite some friends over and pour your creativity and camaraderie into making it yourself? Not only will the light and bright end results taste better (and go perfectly with a side of No Mistake Herbed Rice [page 89]), the memories you make and share will last longer than any meal.

SERVES 4

1 pound/460 g large shrimp (26 to 30 count)

1 cup/220 g unsalted butter

1/4 cup/60 ml white wine

2 tablespoons/30 ml freshly squeezed lemon juice

1/4 teaspoon salt

2 tablespoons/10 g finely chopped fresh parsley

2 tablespoons/20 g minced garlic

1/4 cup/30 g breadcrumbs

Cooking spray

Preheat the oven to 350°F/180°C.

Place the shrimp in a pot and cover with water. Don't want them to fall out of the water and make a big splash, so gently bring them to a boil and cook until the shrimp turn pink, then drain.

In an ovenproof skillet, combine the butter, wine, lemon juice, salt, parsley, and garlic. Melt the mixture over medium heat. Add the shrimp, fully coat with the mixture, and sprinkle the breadcrumbs on top. Spray breadcrumbs with cooking spray.

Place in the oven and bake, uncovered, for about 15 minutes.

Rascal Shrimp

Rocks come in different shapes, trees have gnarled branches, rivers take unexpected turns, and clouds never look the same way twice. These little rascals aren't examples of nature's imperfections; they're the very elements that give our world a wonderful variety of textures, flavors, and experiences. Blended with the more subtle roasted red peppers, rascally crushed red pepper flakes give this dish a wonderful and unexpected jolt of spice.

SERVES 4

¼ cup/60 g unsalted butter

2 tablespoons/30 ml olive oil

⅓ cup/60 g chopped onion

6 garlic cloves, minced

1½ pounds/680 g large shrimp (about 26 to 30 little shrimp friends in total)

½ teaspoon crushed red pepper flakes

12 ounces/340 g roasted red peppers, chopped

½ cup/120 ml white wine

½ cup/120 ml heavy whipping cream

1 cup/100 g grated Parmesan cheese

¼ cup/10 g chopped fresh basil

In a skillet, heat the butter and oil together over medium heat until the butter is melted. Add the onion and garlic and cook, stirring until the onion is softened. Add the shrimp and red pepper flakes, and cook, stirring, for about 2 minutes. Add the roasted red peppers and wine.

Bring to a boil, then lower the heat and simmer for 2 minutes, or until the shrimp are opaque. Stir in the cream and ½ cup of the Parmesan cheese and simmer for 2 minutes, or until heated through. Don't rush it by raising the heat. Just let it happen. Let it happen.

Stir in the basil. Top with remaining Parmesan cheese, to serve.

Bravery Test Gradually increase the amount of red pepper flakes to your taste, balancing the amount of heat and flavor that works for you!

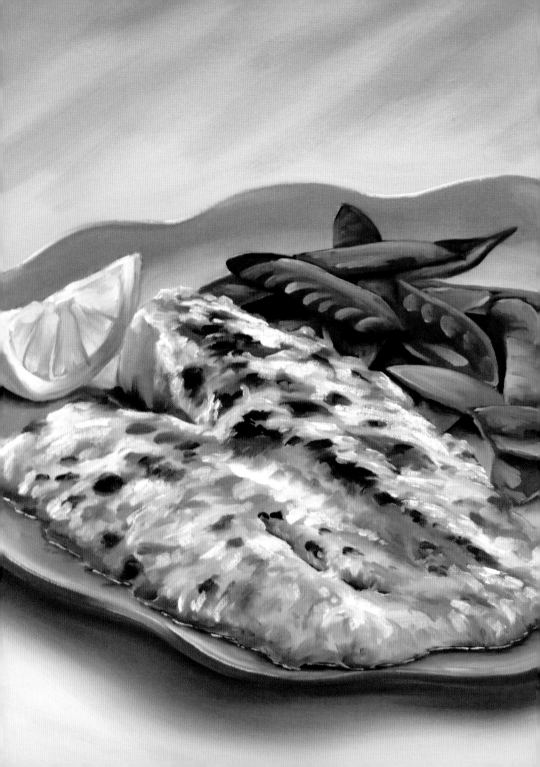

Dockside Broiled Tilapia

The ponds and streams that Bob loved walking beside, talking about, and of course, painting, were often teeming with fish just below the surface. Tilapia's mild flavor is the perfect canvas to absorb and bolster the creamy bold mustard.

SERVES 4

Nonstick cooking spray (optional)

3 tablespoons/40 g mayonnaise

¼ cup/30 g breadcrumbs

½ teaspoon Dijon mustard

½ teaspoon freshly squeezed lemon juice (have you ever seen a lemon tree in person? They're so cheerful!)

2 tablespoons/10 g grated Parmesan or Romano cheese, divided

1 pound/460 g tilapia (about 4 fillets)

Preheat the oven to 450°F/230°C. Have ready a nonstick sheet plan or spray a sheet pan with nonstick cooking spray.

In a small bowl, combine the mayo, breadcrumbs, mustard, lemon juice, and half of the cheese until the mixture forms a paste.

Place the fish on the prepared sheet pan. Top each fillet with the paste, then sprinkle evenly with the remaining cheese.

Bake for 20 minutes, or until the topping is browned lightly and the fish flakes with a fork.

Seaside Salmon

Chances are, Bob never caught a lot of wild salmon furiously swimming up——or down——stream. But, no matter—this recipe is as wonderful a way to end a day on the water as it is to end a day of painting. And if you weren't able to catch a big one, your fishmonger will be happy to not only direct you to the best and freshest catch of the day, but will fillet the fish for you, too!

SERVES 2

2 tablespoons/30 ml soy sauce (I prefer low- or no-sodium soy sauce, as the fish will already have a natural saltiness to it)

2 tablespoons plus 1 teaspoon/50 g honey

2 teaspoons grated fresh ginger (grated on a Microplane)

2 salmon fillets

Drizzle of sesame oil

Preheat the oven to 400°F/200°C.

In a small bowl, combine the soy sauce, honey, and ginger.

Place the fillets, skin-side up, on a nonstick baking sheet and coat the top of them with half of the dressing.

Broil for 4 minutes, then flip the fillets and top with the remaining dressing. Broil for another 4 minutes. Add the remaining dressing and drizzle the sesame oil on top.

Bravery Test Add a little more ginger for a stronger kick!

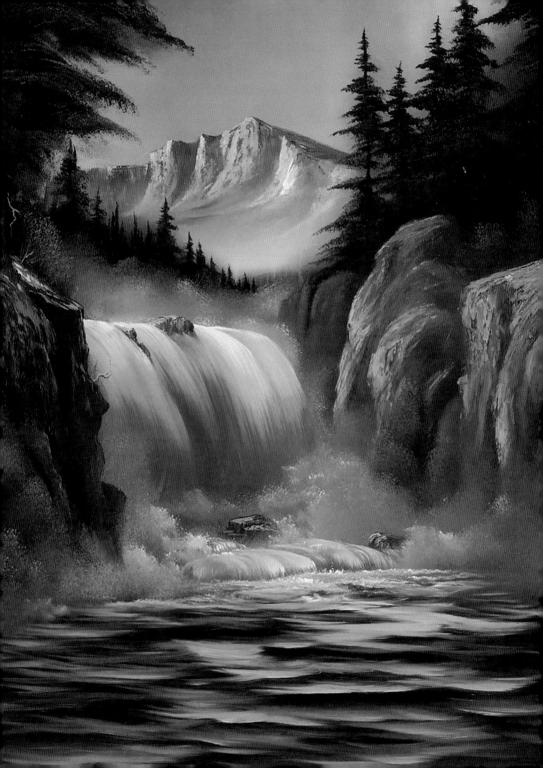

Upstream Salmon Croquettes

Think all fish cakes are made the same? *That's baloney!* These hand-formed croquettes are golden brown on the outside, and filled with a rich yellow-ochre filling, and so good you'll want to swim against the tide for more. These go well with any vegetable, rice, or potato side dish. Best of all, they're made by you, and that makes them special.

SERVES 4

½ cup/60 g plus 6 tablespoons/40 g panko or breadcrumbs, divided

1 (14¾-ounce/420 g) can salmon

1 small onion, diced

1 tablespoon dried chopped onion

½ teaspoon dry mustard

1 teaspoon Old Bay seasoning

1 tablespoon freshly squeezed lemon juice

1½ teaspoons soy sauce

1½ teaspoons Worcestershire sauce

2 squirts of hot sauce

1 large egg (beat the devil out of it)

¼ cup/60 ml olive or vegetable oil

Cover a 9-inch/23 cm pie plate with ½ cup/60 g of the breadcrumbs.

Drain the salmon and remove any large bones.

In a large bowl, use a fork to shred the fish into small bits (I like to use my hands). Add 6 tablespoons/40 g of breadcrumbs and all the other ingredients, then mix until everything is fully incorporated and able to stick together without compressing too hard.

In the bowl, use a knife or your hands to make 2 score lines, dividing the mixture into 4 equal quadrants. Cover the bowl with plastic wrap and refrigerate for 1 hour.

Add enough of the oil to coat the bottom of a small- to medium skillet and heat over medium heat until the oil is hot and shimmery like a sunset on the water.

Remove the chilled fish mixture from the refrigerator and use your hands to create 4 equal-size patties.

Place the patties in the oil and fry for 5 minutes, or until they're a golden brown. Because you don't want to crowd the patties, and depending on the size of your pan, you may need to work in batches. I like to give myself plenty of room to flip, so it usually takes me two rounds. You'll be tempted to move them around, but don't do it as they may still fall apart. Not the worst thing, though, as a happy little accident like this will give you something to nibble on in the kitchen.

Flip once they're golden brown and cook the other side.

Place the patties on a paper towel to soak up any excess oil.

Perfect to serve with Curly Topped Veggie Mac and Cheese (page 70) or rice and roasted vegetables.

Bravery Test If you do use more horseradish, add half a tablespoon more of bread-crumbs to absorb some of the moisture.

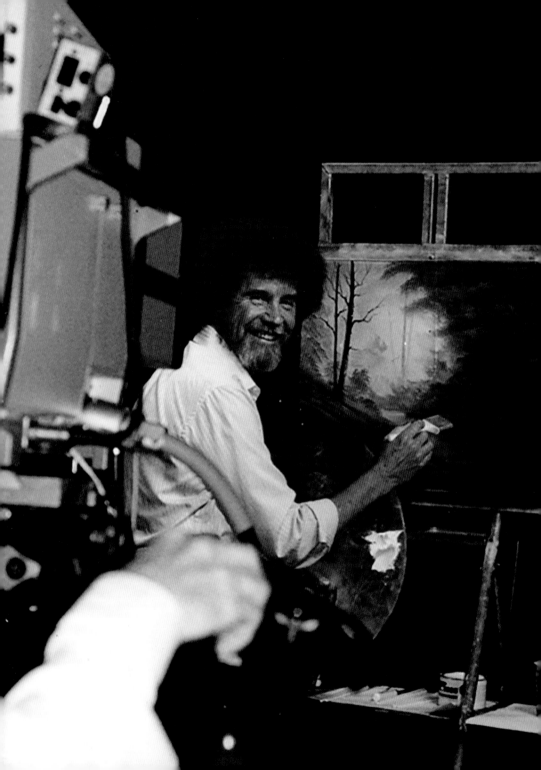

Part Four

Chicken

"We each see the world in our own way. That's what makes it such a special place."

Mediterranean Chicken Potpie

All it takes is a little change of perspective and you begin to see a whole new world.

I like to imagine Bob, not painting in the studio, but along the banks for the Mediterranean, and popping into an Italian-American fusion restaurant to enjoy this hearty meal that blends the classic flavors and colors of a potpie recipe using pre-packaged baking mix. I like making my own, though, as it's less processed and, to my taste, a little lighter in texture. Feel free to use the boxed version, though. It's certainly more convenient! Either way, it's always good, and with an unexpected Italian twist. It's as surprising as it is comforting.

SERVES 6

Unsalted butter for pie plate

1/3 cup/30 g shredded Romano or Parmesan cheese

1¼ cups/140 g shredded mozzarella cheese, divided

1½ cups/210 g shredded Happy Little Roasted Chicken (page 46)

½ teaspoon dried oregano

½ teaspoon dried basil

½ teaspoon garlic powder

1 (6-ounce/170 g) can tomato paste

½ cup/40 g frozen or 1 cup/30 g fresh chopped spinach

½ cup/60 g all-purpose flour

¾ teaspoon baking powder

⅛ teaspoon salt

1½ teaspoons/20 g unsalted butter

1 cup/240 ml whole milk

2 large eggs (beat the devil out of them)

Preheat the oven to 400°F/200°C.

Butter a 9-inch/23 cm pie plate and sprinkle the Romano cheese onto the bottom and sides to evenly coat.

In a large bowl, mix together ½ cup/60 g of the mozzarella cheese, chicken, oregano, basil, garlic powder, tomato paste, and spinach and add to the pie plate, spreading evenly.

Combine the flour, baking powder, salt, and butter in a medium bowl and mix until the butter is coarsely incorporated throughout but not lumpy. Whisk in the milk and eggs until smooth. Pour over the chicken mixture.

44

Bake, uncovered, for 35 minutes, or until golden brown. Sprinkle the remaining mozzarella cheese on top and bake for another 5 minutes, or until the cheese is melted.

Let cool for 5 minutes before serving.

Bravery Test Sprinkle a few (or more) drops of your favorite hot sauce onto the chicken. It'll add flavor and a little moisture.

Happy Little Roasted Chicken

There's nothing as satisfying as a simple happy little roast chicken dinner. And the best part of this recipe is that by cooking the chicken and vegetables together, their flavors, like all good friends, blend together to make something even more delicious! This is one of those dishes for which all the ingredients could be found at your favorite local farmers' market. It's a meal that supports local farmers and, if bought the same day as you're cooking it, will taste as fresh as possible.

SERVES 4

1 (4- to 5-pound/1.8 to 2.3 kg) chicken

1 pound/460 g of your favorite root vegetables (I like carrots or sweet potatoes, but this is your dinner—you can use whatever you like!)

1 large onion, cubed

Drizzle of olive oil

4 tablespoons/60 g unsalted butter, at room temperature

Salt and freshly ground pepper

2 tablespoons/5 g fresh thyme, finely chopped

2 tablespoons/3 g fresh rosemary, finely chopped

1 garlic head, sliced in half lengthwise

1 medium onion, quartered

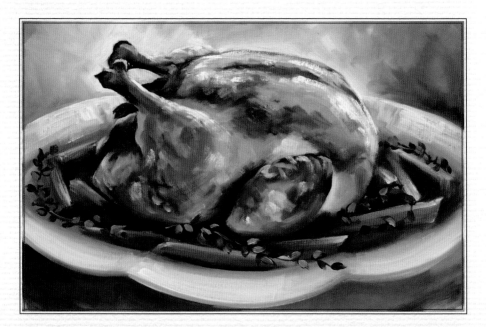

Preheat the oven to 425°F/220°C.

If needed, clean the chicken inside, removing the giblets. But don't throw them away—they can be frozen and, when you're ready, used with other leftover chicken pieces and bones to make a great stock. Isn't that great?

Peel and roughly chop the root vegetables into bite-size pieces, then toss them and the cubed onion into a roasting pan large enough to also fit the chicken and coat them with a light drizzle of olive oil. Once they're evenly coated, spread them out into a single flat layer. Set aside.

In a small bowl, mix together the butter, a pinch each of salt and pepper, and the thyme and rosemary. You should end up with a lovely yellow paste with bright and deep green sparks of happiness. Divide in two and set aside.

Insert the head of garlic and the quartered onion into the cavity of the chicken. Sprinkle the outside of the chicken with a little salt and pepper. Why not?

Use your hands to spread half of the butter mixture under the skin. Don't forget the bottom! Be careful not to tear the skin, but if you do, just use the tear as a little flap to help you get further underneath. Use a basting brush to spread the rest of the butter on the top and all around the bird.

Place the chicken directly on top of the vegetables in the pan. They'll create a nice lift so the chicken won't get stuck to the bottom, and will let the juices flow up and down and all around like a babbling brook.

Roast in the oven for 1½ to 2 hours, until the juices run clear between the thigh and body of chicken, or the internal temperature of the chicken is 165°F/74°C. The chicken should be golden brown; and the vegetables, fork-tender.

Cover with foil and roast for another 15 minutes to seal in the juices. Remove from the oven and let stand for about 10 minutes before carving.

Serve the chicken on the same plate as the roasted vegetables. The different colors and textures will form a beautiful palette!

It's just that easy!

Bravery Test Add 1½ teaspoons of paprika and/or cayenne pepper to the butter mixture to give your meal a spicy kick.

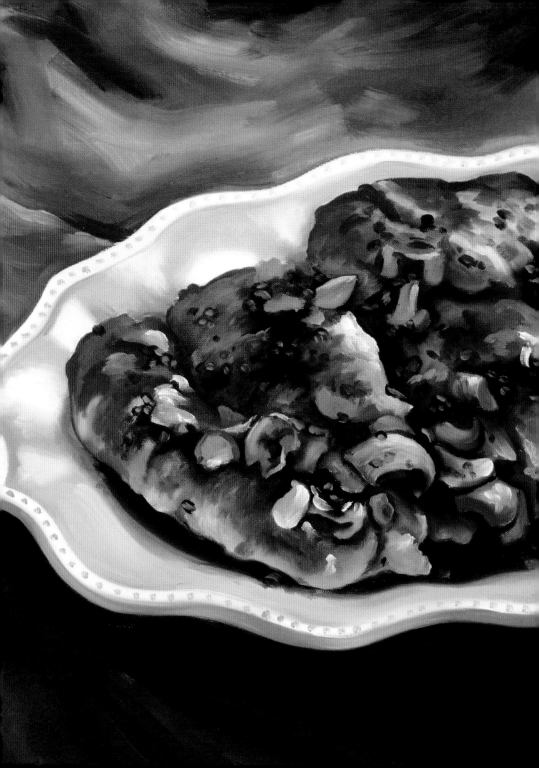

Why Not Wine? Chicken

So many people worry about making mistakes when they're painting. But as Bob taught us, there are no mistakes, just happy accidents. The same goes for those who worry about cooking with wine. If, for example, during the cooking process, a sip or two of beautifully red marsala wine winds up in an aperitif glass (and between your lips) instead of the roasting pan, then that's just a happy accident!

SERVES 4

¼ cup/30 g all-purpose flour

¼ teaspoon salt

⅛ teaspoon freshly ground pepper

½ teaspoon dried thyme

4 boneless, skinless chicken breasts

3 tablespoons/40 g unsalted butter, divided

1 tablespoon olive oil

1 cup/240 ml chicken stock

½ cup/120 ml dry marsala wine

2 cups/140 g sliced mushrooms

2 tablespoons/20 g chopped shallots

Combine the flour, salt, pepper, and thyme in a shallow dish.

Dredge the chicken breasts in the mixture, coating each side.

In a large skillet, heat 1 tablespoon/10 g of the butter and the oil over medium-high heat. Reserving the leftover flour mixture, add the chicken to the pan and cook for 5 minutes per side.

Meanwhile, add the stock and wine to the reserved flour mixture.

Remove the cooked chicken from the pan and set aside. Add the mushrooms and shallots to still-warm skillet and cook until tender. Add the marsala mixture and stir until thickened and bubbling. Whisk in the remaining 2 tablespoons/30 g of butter until incorporated. Pour over the chicken and serve.

Yellow Ochre Chicken

Although the color will vary based on which mustard you're using, I find the beautiful hue that comes from Dijon mustard is matched only by its rich yet not overpowering flavor. The type of mustard you use isn't something you should labor over or worry about. Enjoy it!

SERVES 4

¼ cup/30 g all-purpose flour

¼ teaspoon freshly ground black pepper

4 boneless, skinless chicken breasts

2 tablespoons/30 g unsalted butter

1 scallion, chopped

⅓ cup/80 ml heavy whipping cream

3 tablespoons/50 ml chicken stock

3 tablespoons/30 g Dijon mustard

Combine the flour and pepper in a shallow dish.

Dredge the chicken breasts in the mixture, coating each side.

In a large skillet, heat the butter over medium heat until shimmery. Add the chicken; cook for about 5 minutes per side, or until golden. Remove from the pan and let cool.

Add the scallion and cook for about a minute, or until soft. Stir in the cream, stock, and mustard until smooth and thick. Add the chicken back to the pan and warm through, until the juices run clear.

Bravery Test Experiment with different mustards. Try truffle, horseradish, or coarsely ground mustard!

No Explanation Lemon Chicken

Although Bob's wet-on-wet method of painting was all about adding layers of paint to his canvas, he was never one for imbuing his paintings with layers of meaning or subtext. A mighty tree was a mighty tree. A happy cloud had happy friends up in the sky, and a cabin was put together with a practical carpenter's sensibility, without fancy additions. This dish is what it is: easy and accessible, featuring a bright pop of sunshine lemon flavor. Isn't that great?

SERVES 4

¼ cup/30 g all-purpose flour

¼ teaspoon salt

2 teaspoons lemon pepper

4 boneless, skinless chicken breasts

5 tablespoons/70 g unsalted butter

2 lemons, sliced thinly

2 tablespoons/30 ml freshly squeezed lemon juice

Combine the flour, salt, and lemon pepper in a shallow dish.

Dredge the chicken breasts in the flour mixture, coating each side. Take your time.

In a large skillet, heat the butter until melted. Add the chicken, cooking for about 6 minutes per side, or until golden. Remove from the pan and let cool.

Add the lemon slices to the skillet until they cover the entire bottom of the pan. Sauté for about 2 minutes per side.

Add back the chicken on top of the lemon slices and pour the lemon juice on top. Cook for about 3 minutes, or until the liquid is reduced slightly and chicken juices run clear.

"If I paint something, I don't want to have to explain what it is."

"Be so very light.
Be a gentle
whisper."

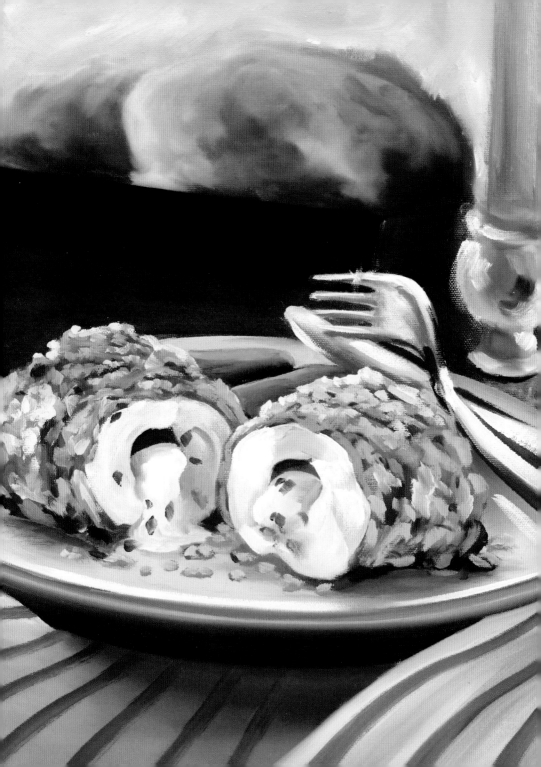

Whisper Chicken

Bob Ross is undeniable proof that you don't have to be the loudest voice in the room to command—or deserve—respect. Boisterousness does not equal intelligence, and swagger has nothing to do with ability. This dish may not set your taste buds on fire, but by leaning in to its simplicity, it owns its place as a main dish that can be welcome on any dinner table.

SERVES 4

4 thin chicken breasts, butterflied

5 tablespoons/70 g butter, at room temperature, divided

4 slices Swiss cheese

1 tablespoon Italian seasoning

⅛ teaspoon garlic powder

⅛ teaspoon onion powder

1 large egg, mixed with 1 teaspoon water

¼ cup/30 g breadcrumbs

1 tablespoon olive oil

Preheat the oven to 400°F/200°C.

Flatten each of the chicken breasts. Place 1 tablespoon of the butter and 1 slice of cheese onto the middle of each. Sprinkle with the Italian seasoning, garlic powder, and onion powder. Roll the breasts so the butter and cheese are wrapped inside; feel free to use a toothpick to keep each one closed.

Brush the breasts with the egg mixture, then coat with the breadcrumbs.

Heat the oil and remaining tablespoon of butter in a large skillet over high heat.

Add the chicken and cook for 6 minutes per side, or until golden brown. Place in oven and bake 15-20 minutes until cooked through and the cheese is melted and peeking out to say hello! Remember to remove the toothpicks before serving.

Bravery Test Try a different melting cheese, such as Muenster, Cheddar, or goat cheese!

Your World Chicken with Mushrooms

Life can get a little hectic sometimes, so it's always nice to take some time, take a few deep breaths, and do something that's just for you. Ready in about the length of an episode of *The Joy of Painting*, this recipe is flavorful, but not too overwhelming or difficult, and a wonderful restorative that you, and you alone, can control.

SERVES 4

½ cup/60 g all-purpose flour

¼ teaspoon salt

¼ teaspoon freshly ground black pepper

1 tablespoon Italian seasoning

4 boneless, skinless chicken breasts

2 teaspoons olive oil

3 tablespoons/40 g unsalted butter

8 ounces/230 g mushrooms, sliced

1 small onion, chopped

1½ cups/360 ml chicken stock

Combine the flour, salt, pepper, and Italian seasoning in a shallow dish.

Dredge the chicken breasts in the flour mixture, coating each side.

In a large skillet, heat the oil until shimmery. Add the chicken and cook for about 6 minutes per side, or until as golden as a sunset over a mountain range. Remove from the pan and let cool.

Add the butter to the still-hot pan. When melted, add the mushrooms and onion and sauté for 6 minutes, or until golden brown. Add the stock and bring to a boil. Lower the heat, add the chicken back to the pan. and cook for 5 more minutes, turning once.

Remove the chicken from the pan and top with the sauce.

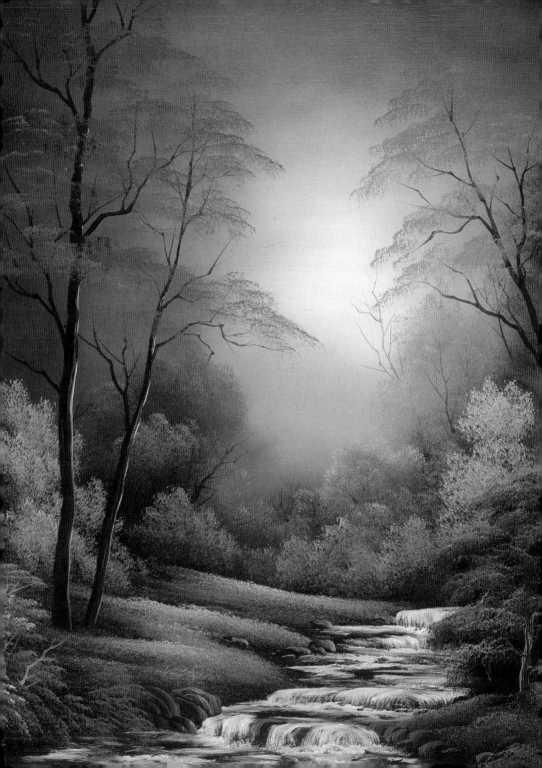

Part Five

Vegetables

"In life, you need colors."

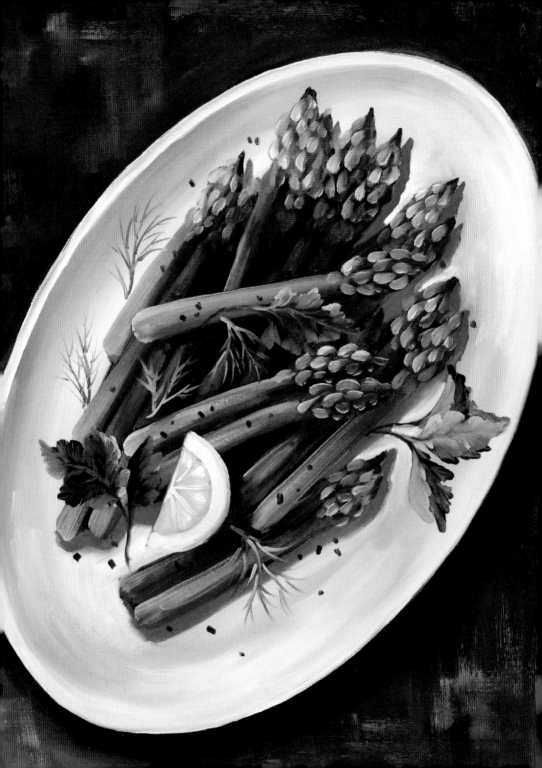

No Big Deal Steamed Spring Asparagus

These sap green-colored happy little trees are at their peak of flavor in springtime, but can be enjoyed all year long. And as they take less time to make than it does to watch an episode of *The Joy of Painting*, they're perfect for any last-minute or rushed dinner.

SERVES 4

1 bunch fresh asparagus (about 12 stalks)

3 tablespoons/40 g unsalted butter, at room temperature

2 teaspoons olive oil

4 teaspoons/scant 10 g lemon pepper

1 teaspoon freshly squeezed lemon juice

Preheat the oven to 400°F/200°C.

Snap off or cut off the tough bottoms of each asparagus stalk. Rub each lengthwise with the butter, coating all sides evenly.

Place the buttered asparagus on a sheet of foil, drizzle with the olive oil, and sprinkle with the lemon pepper and lemon juice.

Bake, uncovered, for 12 minutes, or until the asparagus is cooked but still firm.

"Isn't that something?"

Potato and Onion Are Friends

I think everybody needs a friend. Friends are the most valuable things in the world. And potato and onion are two of my best ones. A versatile duo that pairs with any number of main breakfast, lunch, or dinner dishes, they're at home in any landscape.

SERVES 4 TO 6

8 small red potatoes, sliced into ⅛-inch slices

Drizzle of olive oil

4 tablespoons/60 g unsalted butter

2 small onions, thinly sliced

Salt and freshly ground black pepper

Pat the potatoes with a paper towel to remove any excess surface moisture. I like to keep the skins on the potatoes, as they add a layer of earthy flavor (and nutrients), and crisp up a little differently than the rest of the potato, but if you want something a little less woodsy, then you can peel them.

Heat the olive oil in a medium- to large skillet until shimmery, then add the butter. Once melted, gently place the potatoes in the pan. After about a minute, add the onions.

Try not to move them around too much, but keep an eye and peek under the potatoes, being prepared to flip once they start getting a medium brown color, about 3 minutes. Then flip, so the onions are (mostly) on the bottom. Some can still stay on top of the potatoes, though, as the goal is to blend the flavors but still maximize the exposure to the sizzling oil.

Let cook for another 2 to 3 minutes, or until the onions and potatoes are all rich and crispy.

Transfer to a paper towel–lined plate to absorb the excess oil, and sprinkle with a little salt and pepper.

Bravery Test I love how the simple flavors complement any meat or fish dish, but if you're looking to add a little spice, try sprinkling the mixture with some red pepper flakes, cayenne pepper, or even taco seasoning as they're drying on the paper towels.

Stand Out in a Crowd Zucchini Pie

The tender-but-still-firm green zucchini pops against the soft pale yellow of the pie filling in this wonderful vegetarian brunch main dish. I try not to understand why this dish is so delicious. I just taste it and I enjoy it.

SERVES 6

Nonstick spray for pie plate

1 cup/120 g all-purpose flour

2 teaspoons baking powder

2 zucchini, unpeeled, diced (3 cups/360 g)

1 large onion, diced small

½ cup/120 ml olive oil

4 large eggs (beat the devil out of them)

2 teaspoons Italian seasoning

Salt and freshly ground black pepper

¾ cup/80 g grated Parmesan or Romano cheese, divided

Preheat the oven to 350°F/180°C. Spray a 9-inch/23 cm pie plate with nonstick spray.

Sift the flour with the baking powder into a large bowl, then add the zucchini, onion, oil, beaten eggs, Italian seasoning, salt and pepper to your preference, and all but ¼ cup/30 g of the grated cheese.

Pour into the prepared pie plate, then top with the reserved cheese.

Bake until the top is caramel brown and a toothpick inserted into the center comes out clean, about 40 minutes.

Bravery Test To satisfy those who can't go one meal without meat, add browned sausages before baking, and top with crumbled bacon for a full breakfast experience.

"Probably one of the biggest mistakes made in clouds is overworking them."

Happy Garlicky Potato Clouds

Mashed potatoes are the first thing I think of when I imagine comfort food. As satisfying as they are hearty, and as versatile a side dish as ever made, they're an ideal palette for any flavor you want to experiment with. I find the addition of roasted garlic and cream cheese gives them a savory and rich profile that tastes as good as it smells. And although you can certainly mash the potatoes with a masher or fork, try a different technique by using a ricer or hand-operated food mill to break them down. It may take a bit of time to get used to, but as Bob said, "We're teaching technique here." It'll provide a fluffier, less overworked consistency than you may get from a traditional masher, which may help you avoid a gluey or chunky consistency.

SERVES 4

2½ pounds/1.1 kg potatoes, cubed

5 garlic cloves

1 tablespoon olive oil

1 cup/230 g cream cheese

4 tablespoons/60 g salted butter

Preheat the oven to 375°F/190°C.

Place the potatoes in a large pot and cover with water. Bring to a boil over high heat, then lower the heat to low and simmer covered for 20 minutes, or until the potatoes are fork-tender.

Meanwhile. coat the garlic cloves with the olive oil, place on a baking sheet or any oven-safe dish and roast in the oven until soft, about 10 minutes. Remove from the oven and let cool.

Drain the potatoes; do not rinse. Run half of them through a ricer or food mill atop the still-hot pot they were cooked in.

Stir in the garlic, cream cheese, and butter until they start to melt, then add the remaining riced or milled potatoes.

Gently fold the potato mixture in the pot so the cheese and butter are fully incorporated but the potatoes are fluffy, not unlike little clouds incorporated throughout. But don't worry if you get some lumps. Just relax, be calm, be peaceful. Let it go.

Cabin Roasted Vegetables

So many of Bob's scenes feature solitary cabins. Whether in verdant woods or a snow-covered field, these cabins are always simple structures with, one can imagine, not a lot of kitchen space. I like to think of the residents of these modest homes enjoying simple, easy-to-prepare meals made of vegetables grown in their own gardens. This is one of those recipes that, though intended as a side dish, can also be a main for vegetarians or anyone looking to go meatless for a day or more.

SERVES 6

2 pounds/900 g of your favorite vegetables, such as happy little broccoli trees, carrots, Brussels sprouts, onions, and mushrooms

4 garlic cloves

1 tablespoon olive oil

Salt and freshly ground black pepper

1½ teaspoons fresh thyme

1½ teaspoons fresh rosemary

Preheat the oven to 450°F/230°C.

Wash and dry all the vegetables, cutting the happy little broccoli trees down into 1- to 2-inch/2.5 to 2 cm florets and dicing the other vegetables.

Use a brush to paint the vegetables and garlic with a thin coat of olive oil.

Place the vegetables on a roasting pan or cookie sheet and sprinkle the salt, pepper, and herbs on top.

Roast for 15 minutes, then stir and return the mixture to the oven until browned and tender. Be careful not to let them burn—it's very easy to add more color, but it's a son of a gun to try to take it off!

Bravery Test For those who need meat added to every dish, try adding in a pound/460 g of cooked, seasoned sausage meat.

Curly Topped Veggie Mac and Cheese

As kid-friendly as can be as a side dish or main meal, the curly corkscrew-like pasta shape used in this mac and cheese is more than a reminder of Bob's famous hairstyle—it provides lots of hiding places in each forkful for the cheese and veggies to get into. Isn't that great? Because it's a favorite, this is the perfect dish to make with, and not just for, children. They'll love being involved in the process, and feel a sense of accomplishment when it's done. And success (with painting or cooking) leads to success with many other things. It carries over into every part of your life. What a gift to share with the next generation.

SERVES 6 TO 8

Non-stick cooking spray, for baking dish

12 ounces/340 g fusilli pasta

1 pound/460 g fresh happy little broccoli trees, chopped into ½-inch/1.3 cm pieces

1 pound/460 g Cheddar cheese, grated

8 ounces/230 g cream cheese

¼ cup/60 ml whole milk or half-and-half

10 ounces/280 g portobello mushrooms, coarsely chopped

1 tablespoon mustard (I prefer Dijon but yellow deli mustard or any other smooth variety will do)

1 pound/460 g tomatoes, diced and drained

⅓ cup/40 g panko or breadcrumbs

2 tablespoons/30 g salted butter, melted

Preheat the oven to 350°F/180°C. Spray a 12 x 9-inch/30 x 23 cm baking dish with non-stick cooking spray.

In a large stockpot, bring heavily salted water to a boil.

Add the pasta, cover, and cook for about 8 minutes. After about 4 minutes, add the happy little broccoli trees.

Drain, but do not rinse, and return the pasta mixture to the still-hot pot. Stir in the Cheddar cheese, cream cheese, milk, mushrooms, mustard, and tomatoes.

Transfer to the prepared baking dish, sprinkle with the panko, and drizzle the melted butter on top.

Place in the oven and bake for 15 minutes, or until the top is browned and the cheese is as bubbly as a babbling brook.

Bravery Test dd 8 ounces/230 g of cooked, seasoned ground beef (such as broken-up Van Dyke Browned Meatballs [page 13]) to make it an even heartier main dish. Serve with the Work in Layers Wedge Salad (page 84).

Glad You Could Join Me, Grilled Cheese

At the start of each episode of *The Joy of Painting,* Bob took the time to personally welcome viewers to his show. It was a simple gesture that took seconds. I think this greeting meant something to each of us because, quite simply, we knew it was coming from a genuine place within Bob. He appreciated that we were, in turn, welcoming him into our home. I know he was grateful for the opportunity to spend time with us and share his talent. I think this sandwich, especially when paired with A Little More Red Tomato Soup (page 97), embodies the essence of companionship and sincere affection that Bob shared with us, and encouraged us to share with our friends and loved ones. Because each friendship is unique, I'd encourage you and your friends to decide how much cheese (and what type), and how much tomato (if any) to add as you're making the sandwiches. There's no wrong way to do it, and if you find there's too much or not enough, well then, that's a happy accident that lets you make another!

SERVES 4

2 tablespoons/30 g mayonnaise

8 thick slices crusty bread

Butter

Swiss or Cheddar cheese, sliced

Sliced tomatoes

Spread the mayo lightly on 1 side of a piece of bread.

Heat a scant amount of butter in a small to medium skillet. Place the bread, mayo-side down, on the skillet.

Add 1 slice of the cheese and a tomato slice atop the bread

Spread the mayo on 1 side of a second slice of bread and place, mayo-side up, on top of the stack to complete the sandwich.

Grill until lightly browned (you'll need to use a knife—not a brush!—to lift it slightly to inspect the bottom), then flip over. Continue to grill until the cheese is melted and both sides of the sandwich are a deeply browned.

Repeat to grill the remaining sandwiches.

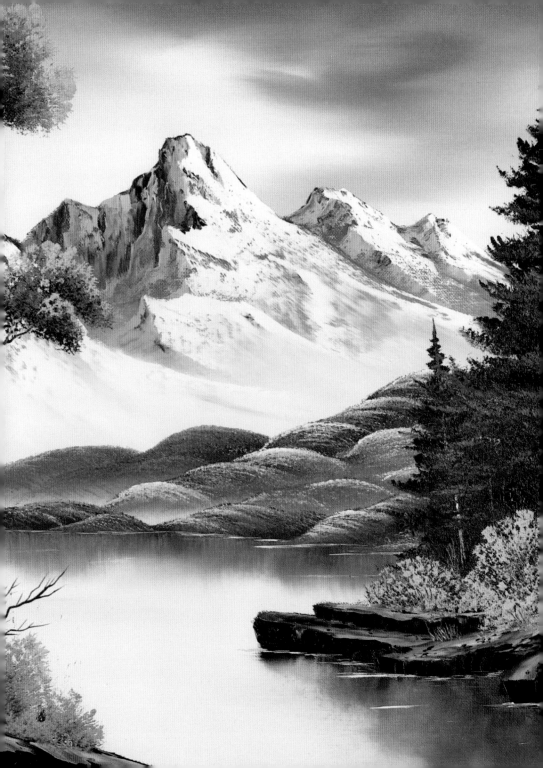

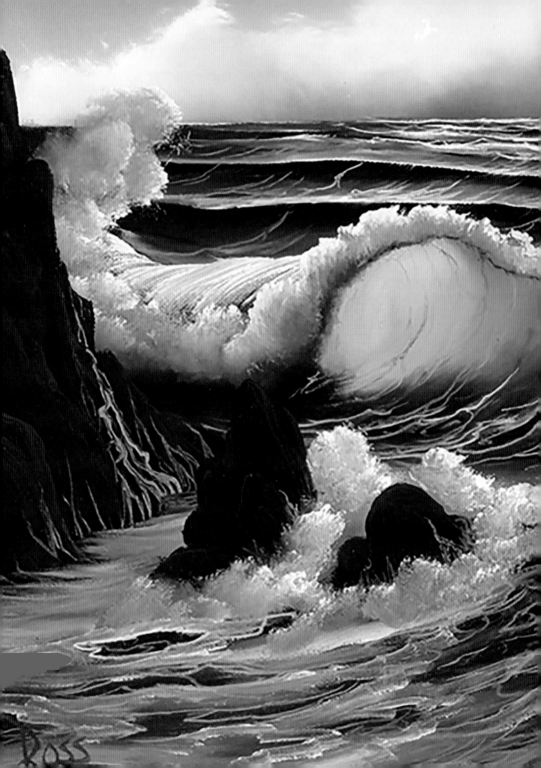

"You have to have
the darkness to balance
out the light."

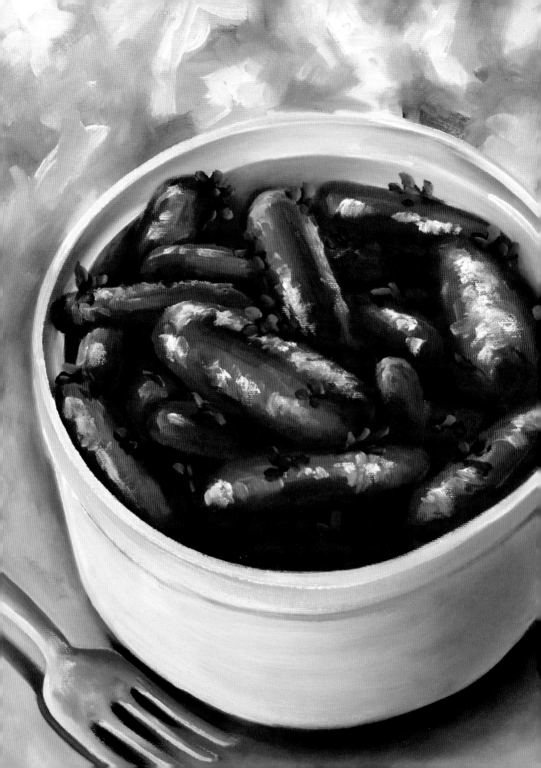

Perfectly Balanced
Sweet Candied Carrots

This dish balances sweetness and acid, while adding a welcome pop of bright orange color. It's a great little friend served beside many meat and chicken dishes.

SERVES 4

2 cups/480 ml/ no-pulp orange juice

1 cup/240 g light brown sugar

1½ pounds/480 g baby or regular carrots, peeled and cut into 2-inch/5 cm pieces

1 tablespoon unsalted butter

1 tablespoon finely chopped parsley

Heat the orange juice in a large saucepan over low heat.

Slowly add the brown sugar, ⅓ cup/80 g at a time, stirring constantly, until totally dissolved. You may want to use a whisk to make sure there aren't any lumps, but a spatula or spoon usually works just as well.

Once the liquid is free from all lumps, increase the heat to medium and add the carrots. All the carrots should be submerged in the liquid. If they're not, either add a bit more juice or remove some of the carrots and enjoy a snack!

Bring to a boil, and then lower the heat to a simmer and cook, covered, for about 15 minutes, or until the carrots are fork-tender. I like to give the carrots a stir every once in a while to make sure they all get to mingle with their friends.

Transfer the carrots out of the liquid and into a bowl; then mix with the butter so they have a sheen that really brings out their bright and rich orange color.

Drizzle with a little of the orange juice from the pot, and top with the parsley for a final burst of color and freshness. They'll make you feel good!

Part Six

Soups, Salads, and Some Other Things . . .

"We don't really know where this goes, and I'm not sure we really care."

Lazy Water Salad Niçoise

I don't think anyone but Bob ever thought he was as lazy as he claimed to be. Between his television show, business, and classes, it's amazing he had any downtime at all. This salad may taste like you've spent hours preparing it, but it's actually pretty easy!

SERVES 4

Salad

1 pound/460 g small fingerling potatoes, cut into 1-inch pieces

3 (3-ounce/85 g) cans tuna, water or oil-packed

6 hard-cooked large eggs, peeled and quartered lengthwise

Salt and freshly ground black pepper

2 medium-size heads romaine lettuce, torn into bite-size pieces

10 cherry tomatoes, sliced in half

1 small red onion, sliced thinly

8 ounces/230 g green beans, trimmed, steamed, and cut into 1-inch/1.5 cm pieces

¼ cup/30 g black olives, sliced

2 tablespoons/20 g capers

Dressing

⅓ cup/80 ml freshly squeezed lemon juice

¾ cup/180 ml extra-virgin olive oil

2 tablespoons/20 g finely chopped shallots

1½ tablespoons/4 g finely chopped fresh basil

1 tablespoon finely chopped fresh thyme

2 teaspoons fresh tarragon

1 teaspoon Dijon mustard

Salt and freshly ground black pepper

Recipe continues.

Boil the potatoes in a medium pot for about 10 minutes until fork tender. Drain and pat dry, and set to the side to cool.

Empty the cans of tuna into a medium bowl (drain water or oil), and gently separate the pieces. You want them to be large enough to be bite-sized, but not smashed or mashed as you would have in a tuna sandwich.

In a large bowl, mix the cooled potatoes and all the other vegetables.

In a medium bowl, whisk all of the dressing ingredients together.

I like to let my guests use their creativity and prepare their own servings, so I place the bowls of salad, tuna, and dressing on the table and let them serve themselves. This way, everyone gets the amount of vegetables, tuna, and dressing that they like! There are no rules!

That's it! Isn't it great to do something you can't fail at?

Bravery Test Add some rinsed anchovies. They'll melt a little in the acid of the dressing and give the each bite a rich, slightly salty flavor.

"Water's like me. It's lazy. Boy, it always looks for the easiest way to do things."

Work in Layers
Wedge Salad

Bob's wet-on-wet technique was all about adding layers of paint on top of layers of paint to create each one-of-a-kind painting. By letting the layers blend and work together, each color took on a deeper and more vibrant hue. Similarly, the layers of this salad, each interesting in its own right, are made even more delicious when combined. But if it's not what you want, stop and change it. Don't just keep going and expect it will get better!

SERVES 4

4 strips bacon

1 head iceberg lettuce, core removed

Prussian Blue Cheese Dressing (recipe
 follows)

1 small red onion, diced

2 small Roma tomatoes, liquid squeezed
 out, diced

¼ cup/30 g crumbled blue cheese for
 sprinkling

Fry the bacon and transfer to a paper towel to cool and to drain any excess fat.

While the bacon is resting, divide the head of lettuce into 4 equal wedges and set on 4 separate plates. Drizzle each wedge, but don't drown it with, the blue cheese dressing. Sprinkle with some of the onion, tomato, and a few extra crumbles of blue cheese.

When the bacon is fully cooled, chop up and sprinkle about 1 strip's worth onto each wedge.

Serve any leftover onions, tomatoes, bacon, or dressing in separate bowls so people can add more deliciousness if they wish.

Prussian Blue Cheese Dressing

Tailor-made to accompany the Work in Layers Wedge Salad (page 84), this dressing works to deepen the flavors of any salad and is great as a dip for crudités or your favorite hot wings.

SERVES 6

4 ounces/120 g crumbled blue cheese

⅓ cup/80 g sour cream

⅓ cup/80 ml buttermilk

¼ cup/60 g mayonnaise

¼ cup/60 ml white wine vinegar

2 teaspoons sugar

¼ teaspoon garlic powder

⅛ teaspoon ground white pepper

In a medium bowl, use a fork or firm spatula to mix together the blue cheese, sour cream, and buttermilk and break up the chunks of cheese. The dressing should be creamy but still with some bits in it.

Add all the other ingredients, mixing gently until smooth.

"This will excite people!"

Summer Scene Simmered Red Onions

Imagine playing ball beneath the bright sun and happy little clouds featured in one of Bob's paintings. Just off the side—out of frame—would surely be a picnic, and you can bet that every hot dog and burger (even the vegetarian ones!) would be topped by this bright red and yellow ochre combination.

SERVES 8 TO 10

2 tablespoons/30 ml olive oil

2 medium-size yellow or white onions, sliced into 1-inch/2.5 cm pieces

¼ cup/60 ml ketchup

½ teaspoon sugar

⅛ teaspoon chili powder

Dash of hot sauce

Pinch of ground cinnamon

1 cup/240 ml water

Heat the olive oil in a large skillet over medium heat. Add the onions and simmer until soft, about 10 minutes.

Mix together the remaining ingredients in a bowl and add to the softened onions. Increase the heat until it reaches a boil, then lower the heat and simmer for an additional 10 minutes. Let those onions flow right out of your heart and onto any burger, hot dog, or sandwich!

No Mistake Herbed Rice

Rice is a lot like a blank canvas upon which you can use an entire palette of ingredients to add any sort of flavors your imagination can think of. Although you can certainly use other varieties of rice, such as white, wild, or arborio (as long as you follow their individual cooking instructions), I prefer using brown rice for its color and slightly more hearty, earthy flavor that pairs well with fish. The end dish will resemble the beautiful green and brown leaves often found on the banks of meandering rivers and streams.

SERVES 4

2 cups/380 g uncooked brown rice

4 cups/950 ml chicken or vegetable stock

3 tablespoons/40 g salted butter

½ cup/30 g finely chopped fresh dill

Salt and freshly ground black pepper

Bring the rice and stock to a boil in a medium saucepan.

Cover and let simmer over medium-low heat for 16 to 18 minutes. Uncover and fluff the rice around with a fork, and then let simmer, covered, for another 14 minutes over low heat, until all of the water is absorbed. You're going to want to check on it, but try your best to keep the lid on and wait!

Transfer the cooked rice to a bowl and stir in the butter. Slowly add the dill until it's evenly distributed throughout, stopping before the mixture becomes more green than brown.

Add a pinch or more of salt and a grind or more of pepper—you may want to add even a little more if you're using vegetable stock instead of chicken stock. Top with an extra sprinkle of dill.

Bravery Test The more you cook, the more you'll be able to visualize the end dish, so allow yourself to experiment with different fresh herbs, such as rosemary or thyme, or add a cup/130 to 150 g of fresh peas, diced carrot, or any vegetable for a great way to add flavor and texture.

"I think it's time we had some fun now."

Really Neat Balsamic Pearl Onions

Pearl onions are one of nature's best-kept secrets. Much milder in flavor and texture than the regular onions we're all more familiar with, these tiny morsels burst with sweet and savory goodness. But be careful; they're slippery little devils and may not want to get on your fork without a fight!

SERVES 6

1½ tablespoons/20 g unsalted butter, divided

1 (14.5-ounce/410 g) package frozen pearl onions

1 to 2 tablespoons/30 ml water, plus more if needed

¼ cup/60 ml balsamic vinegar

1 tablespoon sugar

¼ teaspoon salt

¼ teaspoon freshly ground black pepper

Heat two thirds of the butter in a medium skillet over medium heat. If using frozen onions, add and let simmer for 20 minutes. If using fresh, add the onions along with 1 tablespoon of water and let simmer for 10 minutes.

Lower the heat to low and stir in the vinegar, sugar, and 1 tablespoon/15 ml of water. Cook for 30 minutes, stirring and adding 1 tablespoon of water at a time if the mixture becomes dry.

Add the remaining butter, salt, and pepper and transfer to a serving dish.

Bravery Test If you'd rather use fresh onions, set aside some time—it's going to take a while for you to peel those little devils!

Brunch Palette Quiche

Some of the most beautiful results can come from mixing two already perfect things together. Combining yellow and blue makes green. Mixing red and blue makes purple. And blending lunch and breakfast gives us brunch, which is the perfect time to serve this crowd-pleasing main dish.

SERVES 4

Non-stick cooking spray, for pie plate

8 ounces/230 g potatoes, shredded

3¼ teaspoons olive oil

1 medium-size onion, diced

5 ounces/140 g mushrooms

8 ounces/230 g fresh spinach, chopped

4 large eggs

1 cup/240 ml whole milk or half-and-half

¼ cup/30 g grated Gruyère cheese

Preheat the oven to 400°F/200°C. Spray a 9-inch/23 cm pie plate with nonstick cooking spray.

Line the bottom and sides of the prepared pie plate with the shredded potatoes. Bake until the edges are golden brown, about 15 minutes, remove from the oven, and let cool.

Reduce the oven temperature to 325°F/170°C.

In a skillet, heat the oil over medium-high and sauté the onion until soft and golden brown, about 5 minutes. Add the mushrooms and cook until they're almost all dry, about 7 minutes. Add the spinach and cook for about 30 seconds, or until it just starts to wilt. Transfer the mixture to now-cooled potato pie shell.

In a separate bowl, employ Bob's wet-on-wet method and whisk together the eggs, milk, and cheese. Once fully mixed, pour the mixture over the vegetables in the pie plate. Shake the plate just a little to make sure the egg mixture is thoroughly incorporated throughout and all air bubbles come to the surface.

Bake for 20 minutes, or until fluffy.

Bravery Test Use ½ cup/120 ml of milk and ½ cup/120 ml of plain, unflavored seltzer or sparkling water to give the eggs a little extra fluffiness.

Bright Red Tomato Sauce

There are enough unhappy things in the world. Painting and cooking this versatile sauce is a vibrant mixture of three of Bob's most-used colors—mostly bright red, with just a little bit of sap green and Indian yellow mixed in—should be one of the things that brightens your day. Too thick to paint a canvas with, it is the right consistency for any pasta, or even as a dipping sauce, or substitute for plain old ketchup on burgers.

SERVES 6

14 small Roma tomatoes, peeled, or 1 (28-ounce/800 g) can crushed tomatoes

6 garlic cloves, smashed

1 tablespoon dried thyme

1 tablespoon dried oregano

¼ teaspoon crushed red pepper flakes

2 tablespoons/30 ml olive oil

1 tablespoon sugar

Salt

½ cup/50 g grated Parmesan cheese

In a medium pot, combine all the ingredients, except the Parmesan cheese, adding salt to taste, and simmer, covered over medium-low heat for 1 hour.

Transfer to a blender (or use an immersion blender in the pot) and blend until smooth.

Stir in the Parmesan cheese.

 Bravery Test After blending, add another ¼ teaspoon of red pepper flakes and ½ cup/50 g of chopped black olives to make a variation of a spicy arrabbiatta sauce.

Background Alfredo Sauce

I was going to call this Canvas Alfredo, but that doesn't sound as appetizing, does it? This delicious basic pasta sauce, which not only resembles the color of a basic stretched canvas, is at its best when it serves as a basis for a variety of colors and textures that can be added to it.

SERVES 4

1 tablespoon unsalted butter

3 garlic cloves, crushed to a paste

½ cup/120 ml heavy whipping cream

½ cup/120 ml whole milk

1 large egg yolk

⅓ cup/30 g grated Parmesan cheese

Salt and freshly ground black pepper

Much like blending cadmium yellow, yellow ochre, and titanium white on a palette to create a versatile off-white color that stands out from a canvas, combine the butter, garlic, cream, and milk in a saucepan over medium-low heat. Bring to a simmer and remove from the heat. Whisk in the egg yolk, Parmesan cheese, and salt and pepper to taste, until smooth.

Bravery Test

To give the sauce some pops of color as well as a variety of textures, while sneaking in a ton of added nutritional value for picky eaters, toss in peas, chopped spinach, diced red peppers, or any small or chopped vegetable you like after the egg is whisked in. Let the vegetables cook in the sauce on low for about 5 minutes before serving, to make sure they're heated through but still firm.

A Little More
Red Tomato Soup

From vibrant sunsets to autumnal leaves, so many of Bob's paintings were enhanced by just adding a little more red to the scene. This hearty soup is packed with colorful vegetables, and is, for me, best when paired with a Glad You Could Join Me, Grilled Cheese (page 72). Be careful while eating, though, as your white shirt may not be improved by dripping a little more red on it!

SERVES 4 TO 6

1 tablespoon olive oil

1 medium-size onion, diced small

1 tablespoon minced garlic, or to taste

1 tablespoon Italian seasoning

Pinch of salt

Pinch of freshly ground black pepper

Pinch of red pepper flakes

1 (28-ounce/800 g) can diced tomatoes with garlic and basil, undrained

32 ounces/950 ml vegetable stock

1 tablespoon light brown sugar, or to taste

8 ounces/230 g frozen mixed vegetables (corn, green beans, and carrots are all great)

Grated Parmesan or Romano cheese for serving

In a medium pot, heat the oil over medium high heat, then add the onion, garlic, Italian seasoning, salt and black pepper, and red pepper flakes. Cook, stirring, until onions are soft, about 5 minutes.

Mix in the tomatoes, stock, brown sugar, and frozen vegetables. Bring to a boil, then lower the heat to a simmer. Cook, uncovered, for about 20 minutes, then check for seasonings. It may need a touch more salt. Simmer for another 20 to 25 minutes

Serve in bowls, topped with grated cheese.

Bravery Test Add a pinch of red pepper flakes or even more grated cheese for a spicier and creamier soup.

Happy Little Tree and Cheddar Soup

Bob would be the first person to tell you that every happy little tree needed a friend. So, it's only natural that happy little broccoli trees need friends. And their name is cheese. Delicious on their own, but even better when served together, these pals blend beautifully with a crusty bread or a salad, and of course, when shared with friends.

SERVES 4 TO 6

1 tablespoon unsalted butter

1 pound/460 g happy little broccoli trees

I medium-size onion, chopped

1 medium-size potato, diced

¼ cup/30 g all-purpose flour

3 cups/710 ml vegetable stock

½ teaspoon salt

¼ teaspoon freshly ground black pepper

¼ teaspoon freshly grated nutmeg

1 (12-ounce/360 ml) can evaporated milk

1 cup/120 g shredded Cheddar cheese

Heat the butter in a large pot over medium high heat, then cook the happy little broccoli trees, onion, and potato in the butter until soft. Add the flour and cook, stirring, for about 1 minute, or until it smells nutty. Add the stock, salt, pepper, and nutmeg and bring to a boil. Lower the heat and simmer for 10 minutes.

Transfer to a blender and blend (or use an immersion blender in the pot), but don't overdo it. Leave some texture to the soup!

Transfer back to the pot, if necessary, and, over low heat, add the evaporated milk and Cheddar cheese, stirring until smooth.

"What the heck, enjoy it."

Pull Down
French Onion Soup

So many of Bob's effects in the wet-on-wet technique involve applying an amount of paint to the canvas and then using a brush or knife to pull it down toward the bottom. This creates reflections, mountains, and other features in his landscapes. I think you'll be very tempted to pull the cheese that tops this classic soup down to the bottom to get a bit of sharp creamy goodness in each spoonful! Allow the flavors—everything— to work together to make it an easy and satisfying meal.

SERVES 6

2 tablespoons/30 g unsalted butter

1 tablespoon vegetable oil

5 large onions

1½ tablespoons/20 g minced garlic

½ teaspoon salt

2 tablespoons/20 g all-purpose flour

6 cups beef or vegetable stock

⅓ cup/80 ml marsala wine

1 teaspoon rice vinegar

1 teaspoon Dijon mustard

⅓ cup/40 g shredded Jarlsberg cheese

⅓ cup/40 g shredded Gruyère cheese

Preheat a broiler on low.

Heat the butter and oil in large pot over medium high heat. Add the onions, garlic, and salt and cook until the onions are softened, about 5 minutes.

Lower the heat to low and cook for 45 minutes or until the onions are amber and supersoft.

Stir in the flour and cook, stirring, for 3 minutes, or until aromatic. Add the stock, wine, rice vinegar, and mustard. Bring to a boil, then simmer for 15 minutes.

Pour into 6 oven-safe bowls and top with the shredded cheese. Place under the broiler and broil until the cheese is fully melted.

Earth and Sky Mushroom Soup

I think the combination of earthy mushrooms and lighter-than-clouds cream is a wonderful representation of the breadth of many of Bob's landscapes, which within the space of a canvas, provided a perspective that was able to include everything from the lowliest rock to the highest mountain peak. Yes, it's quicker to open a can, but *don't worry*, because you're the one in control, so it will certainly be tastier! And by creating it yourself, you'll learn what makes a soup taste like a soup, and not what makes a soup taste like a can!

SERVES 4 TO 6

3 tablespoons/40 g unsalted butter

1 pound/460 g white mushrooms, chopped

2¾ cups/650 ml chicken or vegetable stock

¼ cup/60 ml water

¾ teaspoon onion powder

½ teaspoon garlic powder

¾ cup/180 ml milk

¾ cup/90 g all-purpose flour

½ teaspoon salt

½ teaspoon freshly ground black pepper

In a large pot, melt the butter over medium heat and add the mushrooms. Cook for about 5 minutes, or until they're mostly dry.

Add the stock, water, onion powder, and garlic powder and bring to a boil, then lower the heat to a simmer and cook for about 10 minutes.

Combine the milk and flour in a small bowl and add to the soup, along with the salt and pepper. Cook over medium-low heat for 20 minutes

Hard to Stop Spinach and Artichoke Dip

A blend of gorgeous greens that burst with rich creamy flavor, this dip will be the hit of any big gathering. It can be made at home and then heated (or reheated) later if you're bringing it to a party.

SERVES 6

2 cups/450 g mayonnaise

2 cups/160 g shredded Parmesan cheese

¼ cup/120 g cream cheese

2 (14-ounce/400 g) cans artichoke hearts, chopped and drainded

1 pound/460 g spinach, chopped

1 cup/150 g seeded and minced red bell pepper

¼ cup/30 g shredded mozzarella cheese

Preheat the oven to 350°F/180°C,

In a medium bowl, mix together the mayo, Parmesan cheese, cream cheese, artichokes, spinach, and bell pepper. Pour into an oven-safe casserole dish. Top with the mozzarella cheese.

Cover and bake for 15 minutes, or until the cheese is completely melted.

Who knows what will happen if you serve this with chips, pita, crusty bread, crackers, or vegetables—whatever you like! Things that just happen are sometimes more beautiful than things you really sit and plan.

 Bravery Test

Add a few dashes of hot sauce for some heat!

Phthalo Green Bean Casserole

As much an American classic as Bob Ross himself, this side dish doesn't have to be relegated to holidays only. I find the beautiful color and taste of fresh-from-the-farm green beans really stand out against the background flavors in this dish, but canned or frozen work perfectly well.

SERVES 4 TO 6

4 (14.5-ounce/410 g) cans green beans, or 1 pound/460 g fresh, chopped into ½-inch/1.3-cm pieces

1 batch I Like to Get Crazy Onions (page 108)

1 batch Earth and Sky Mushroom Soup (page 103) or 1 (10.5-ounce/311 ml) can cream of mushroom soup and 10.5 ounces of whole milk

In a large bowl, combine the green beans with 1 cup/220 g of I Like to Get Crazy Onions and 2 cups/480 ml of the soup. If you're using canned soup, prepare according to the instructions, which usually involves adding milk, before mixing with the other ingredients.

Gently fold the ingredients together so they're fully blended but you haven't beaten the devil out of the green beans, onions, or mushroom pieces.

Place in an oven-safe dish and top with the remaining I Like to Get Crazy Onions. I like a thick onion crust on top, but if you like less, by all means use less—this is your casserole. You're in control!

Bake for 20 minutes, or until bubbly and the onions are brown and crispy.

I Like to Get Crazy Onions

Even though you think you can only get these crispy onions on top of your burgers at restaurants, you can make them yourself at home. All it takes is a little patience and practice (and oil), but once you've mastered the technique, you'll be making these to top everything!

SERVES 4

Vegetable oil for frying

1 large onion, sliced very thinly

Salt

The amount of oil you use depends on how big your pan is, but there should be enough to completely cover the onions by at least ¼ inch/6 mm.

In a medium, deep skillet, heat the oil over medium heat. Let's get crazy—what the heck! Drop in small batches of onions and cook until they're a deep brown. Remove from the skillet and let drain and cool on a paper towel.

Bravery Test Try adding finely chopped herbs, such as rosemary or thyme, while the onions are cooling to imbue them with an extra layer of interest.

"Anything that you believe you can do, you can do. If you believe strong enough, and you're willing to practice, you can do it!"

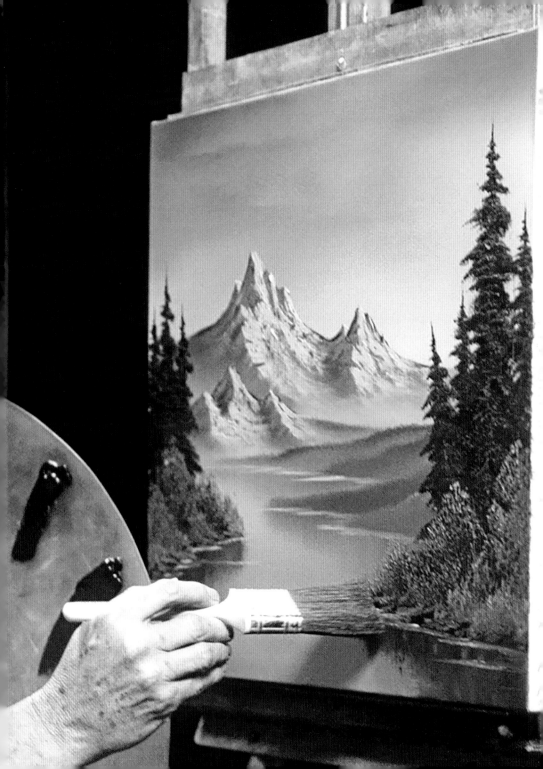

Acknowledgments

Thanks must first go to my editor and friend, Cindy Sipala, for her invaluable support and encouragement, as well as to publisher Kristin Kiser, designer Josh McDonnell, and everyone at Running Press. I'm forever indebted to Joan Kowalski for her trust, and Nicholas Hankins for his beautiful art.

I'm extraordinarily grateful to have my name beside, let alone associated in any way with Bob Ross, and hope he'd be proud of what we've done "together."

Thanks to my dad, Myron, David, and the family and friends who volunteered or were drafted as taste testers.

I learned how to cook by watching, and helping my mom, Harriet. I learned how to do a lot of things that way. This book would never have been possible without her guidance (and recipes!), and though my name's on the cover, this book is as much hers as it is mine.